MUNCH COLOURING BOOK

E.Munch

KONTUR
PUBLISHING

Oil and tempera on unprimed cardboard
83,5 x 66 cm
Munch-museet, Oslo
MM M 514 (Woll M 896)

E.Munch

The Scream (1910)

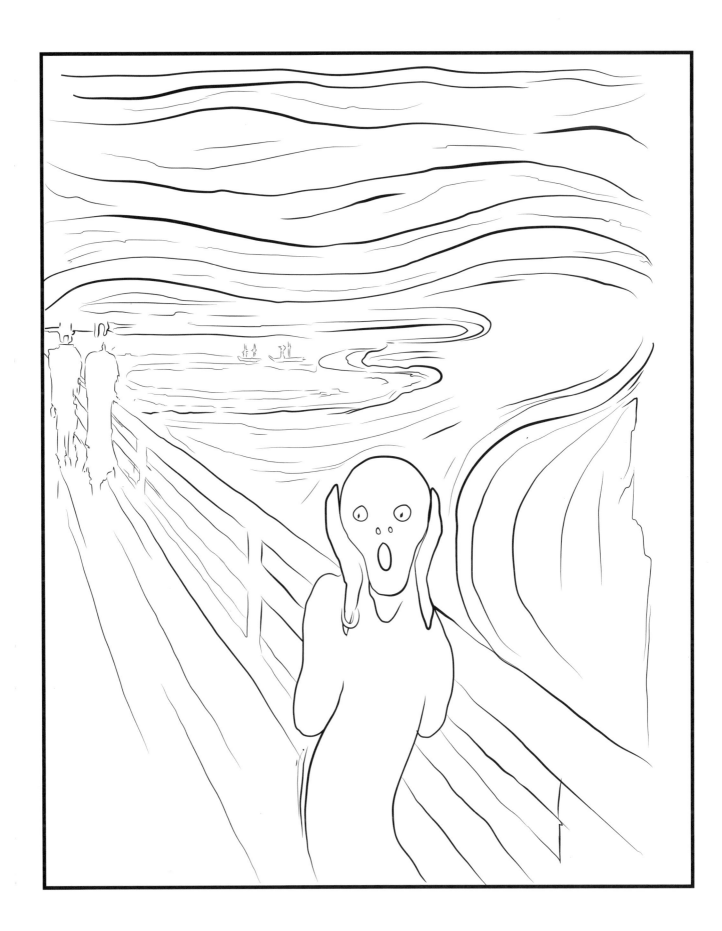

Oil on canvas
136 x 125 cm
Nasjonalmuseet for kunst, arkitektur og design, Oslo
NG.M.00844 (Woll M 483)

E.Munch

The Girls on the Bridge (1901)

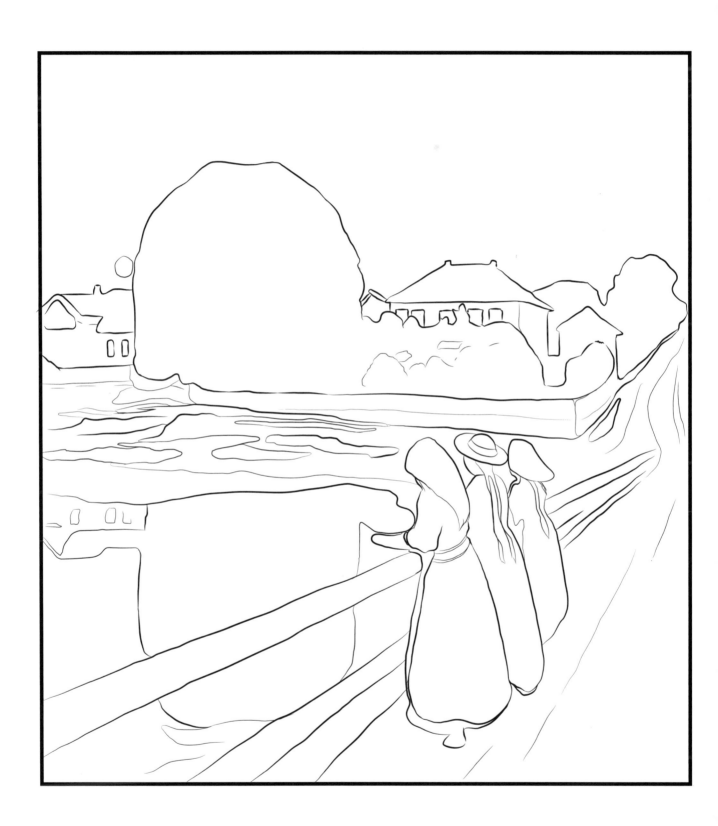

Oil on canvas
125 x 191 cm
Nasjonalmuseet for kunst, arkitektur og design
NG.M.00941 (Woll M 464)

E.Munch

Dance of Life (1899-1900)

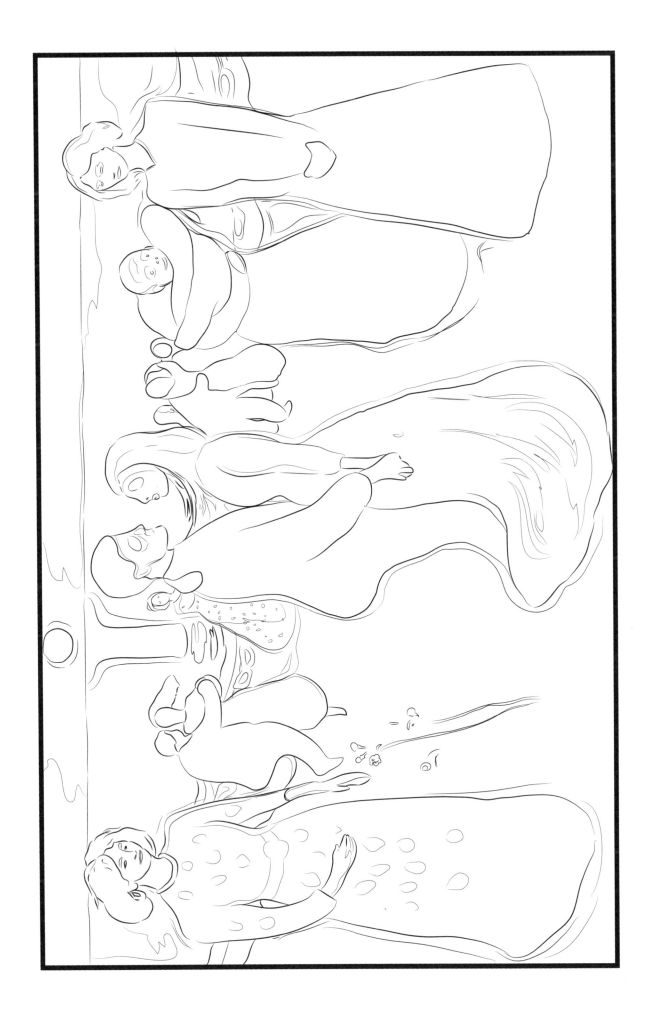

Oil on canvas
90 x 68,5 cm
Munch-museet
MM M 68 (Woll M 365)

E. Munch

Madonna (ca. 1894)

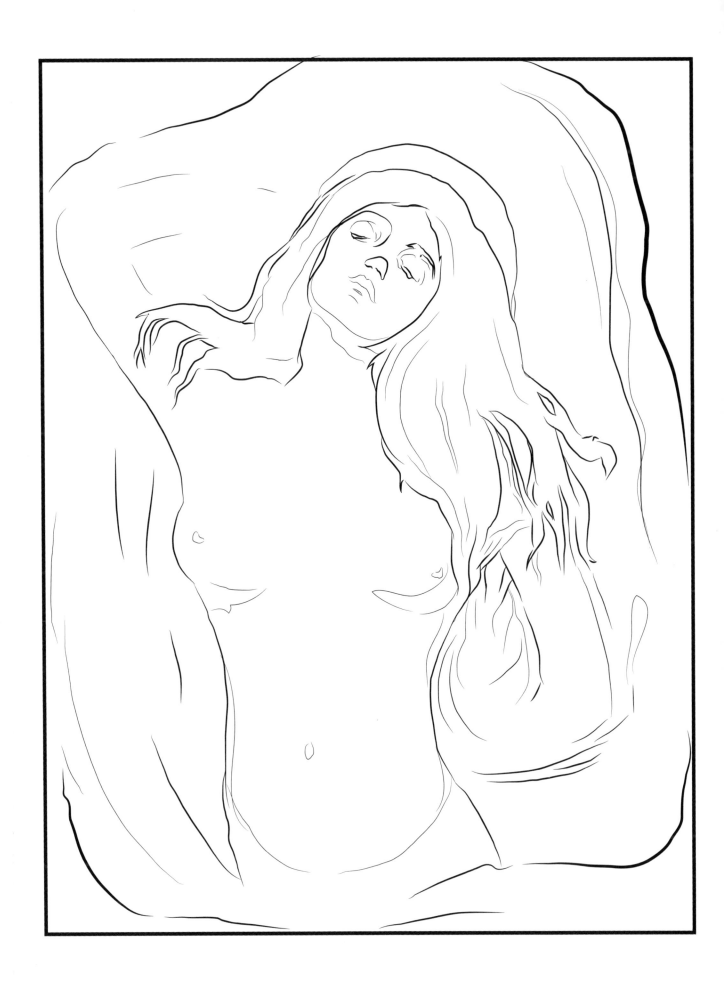

Oil on canvas
79 x 106,5
Nasjonalmuseet for kunst, arkitektur og design
NG.M.02237 (Woll M 495)

E.Munch

The Fairytale Forest (1901-02)

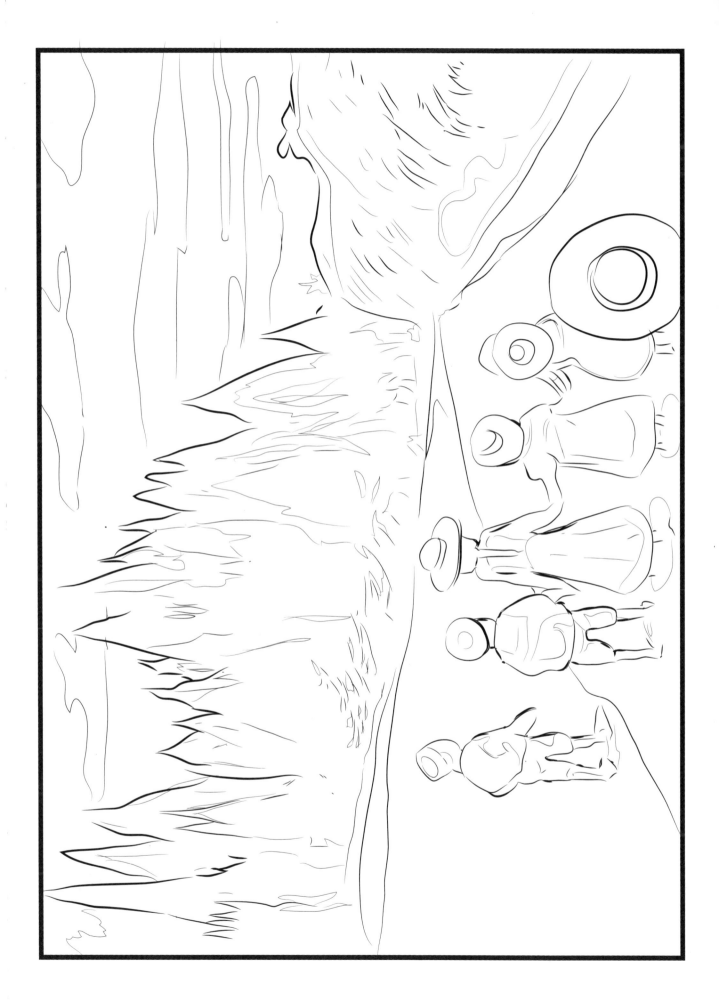

Oil on canvas
93,5 x 129,5 cm
Munch-museet
MM M 460 (Woll M 463)

E.Munch

Red and White (1899-1900)

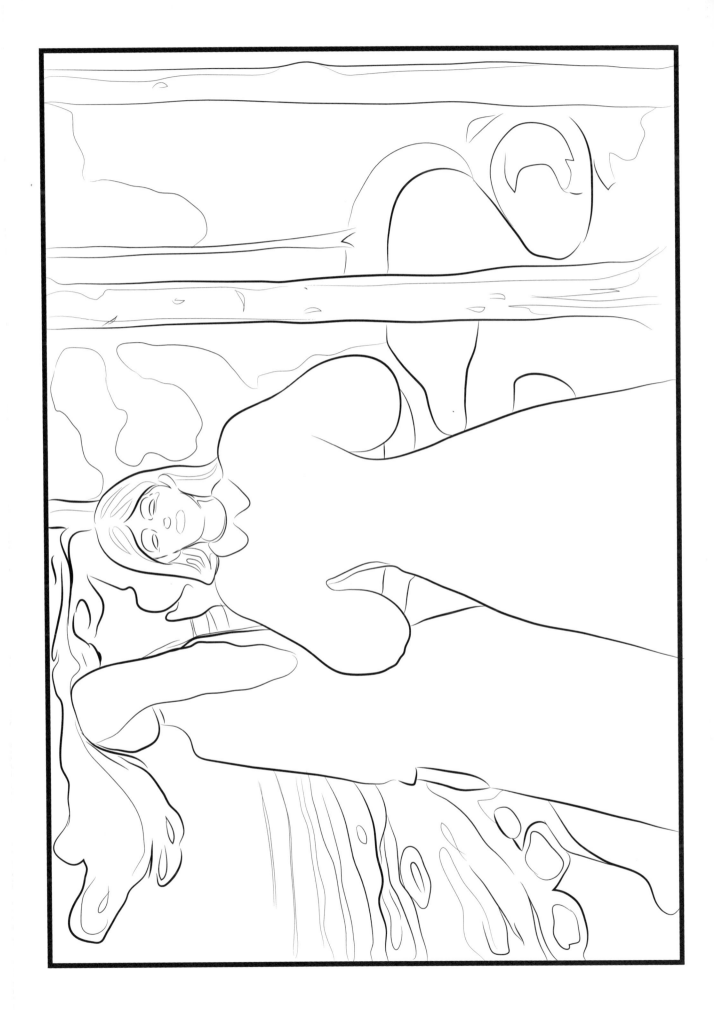

Oil on canvas
94 x 74 cm
Munch-museet, Oslo
MM M 515 (Woll M 363)

E.Munch

Anxiety (ca. 1894)

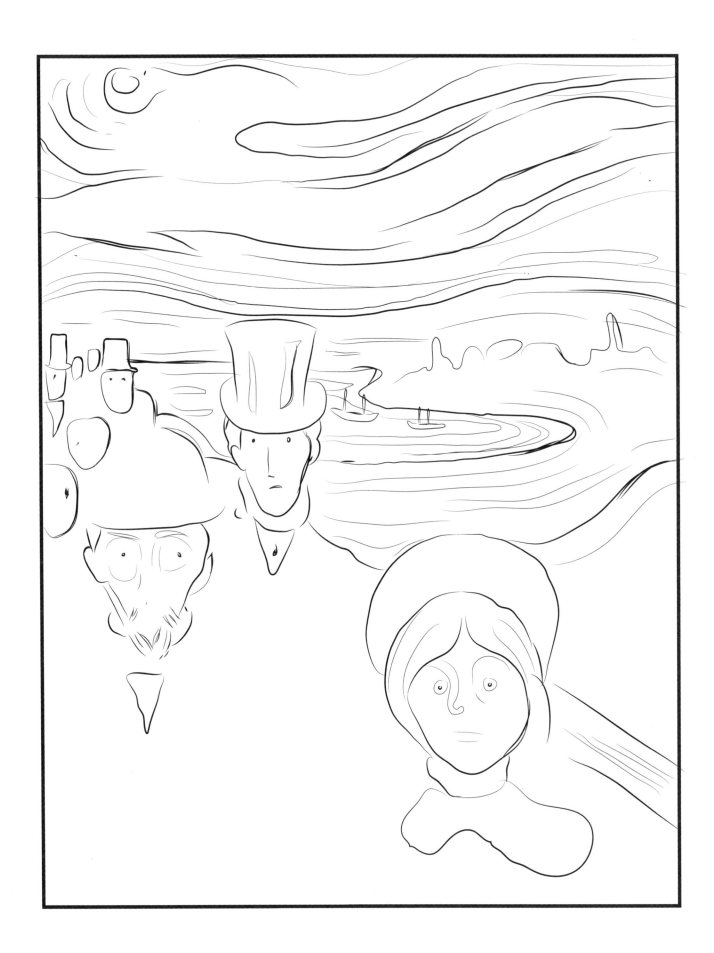

Oil on canvas
109 x 84 cm
Nasjonalmuseet for kunst, arkitektur og design
NG.M.00485 (Woll M 174)

E.Munch

Hans Jæger (1889)

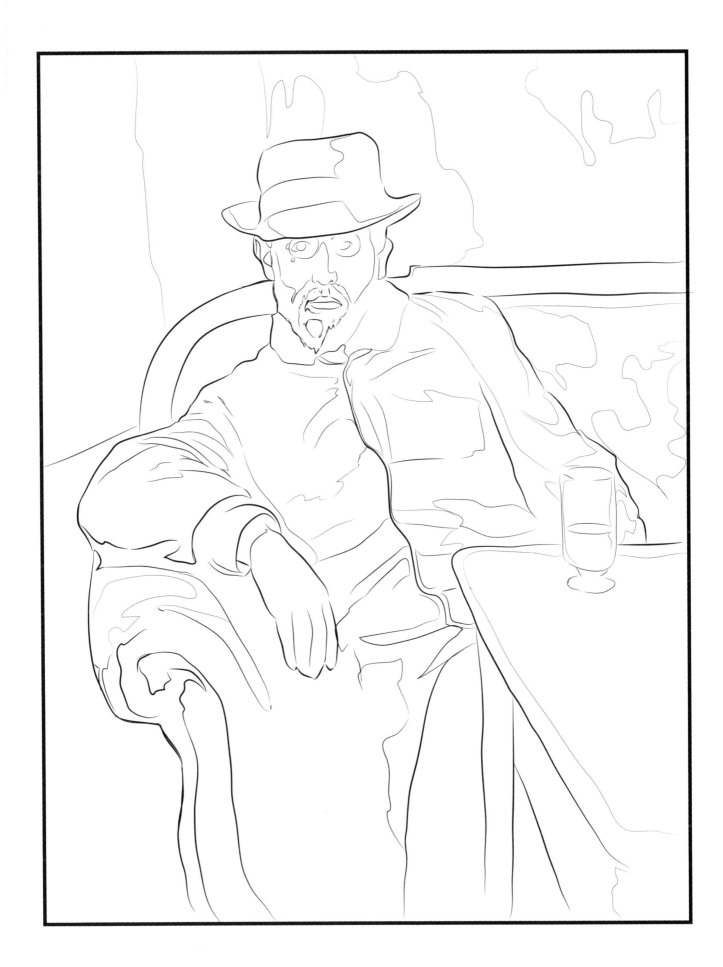

Oil on canvas
151,5 x 110 cm
Nasjonalmuseet for kunst, arkitektur og design
NG.M.00807 (Woll M 347)

E.Munch

Puberty (1894-95)

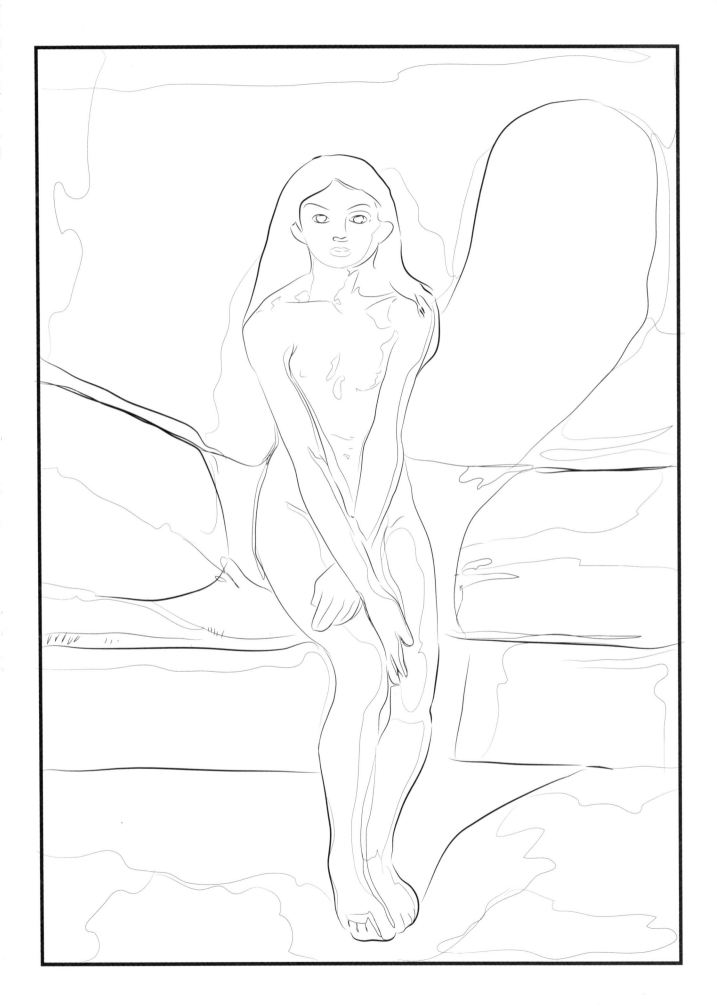

Oil on canvas
90,5 x 130 cm
Munch-museet
MM M 29 (Woll M 1719)

E.Munch

Two Human Beings. The Lonely Ones (1933-35)

Oil on canvas
148 x 120 cm
Munch-museet
MM M 541 (Woll m 875)

E.Munch

Galloping Horse (1910-12)

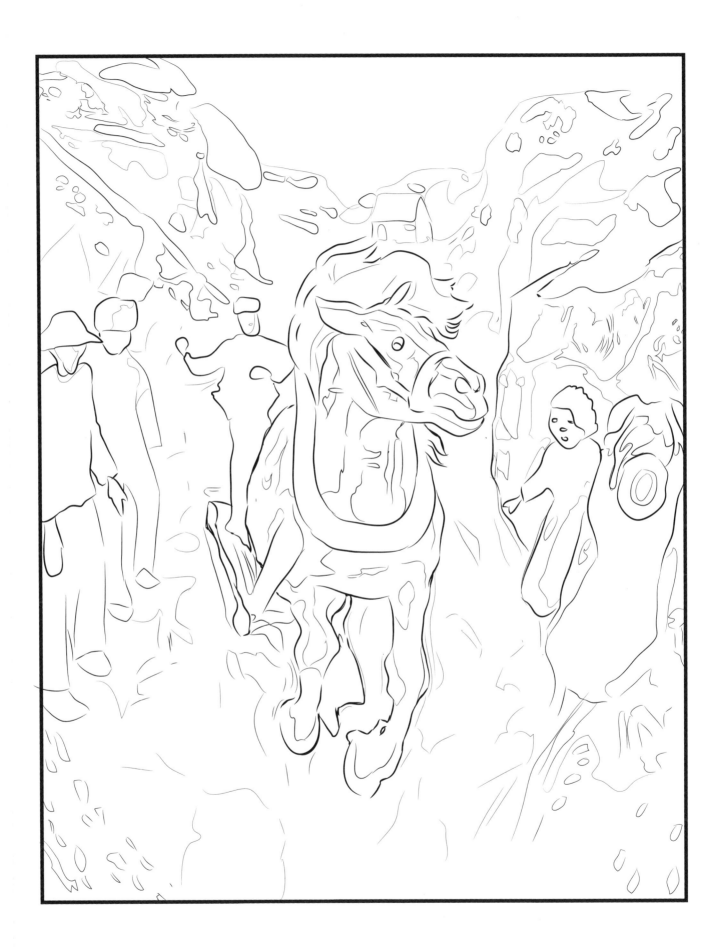

Oil on canvas
123 x 176,5 cm
Munch-museet
MM M 822 (Woll M 1019)

E.Munch

The Sun (1912)

Oil on canvas
91 x 109 cm
Munch-museet
MM M 679 (Woll M 377)

E. Munch

Vampire (1895)

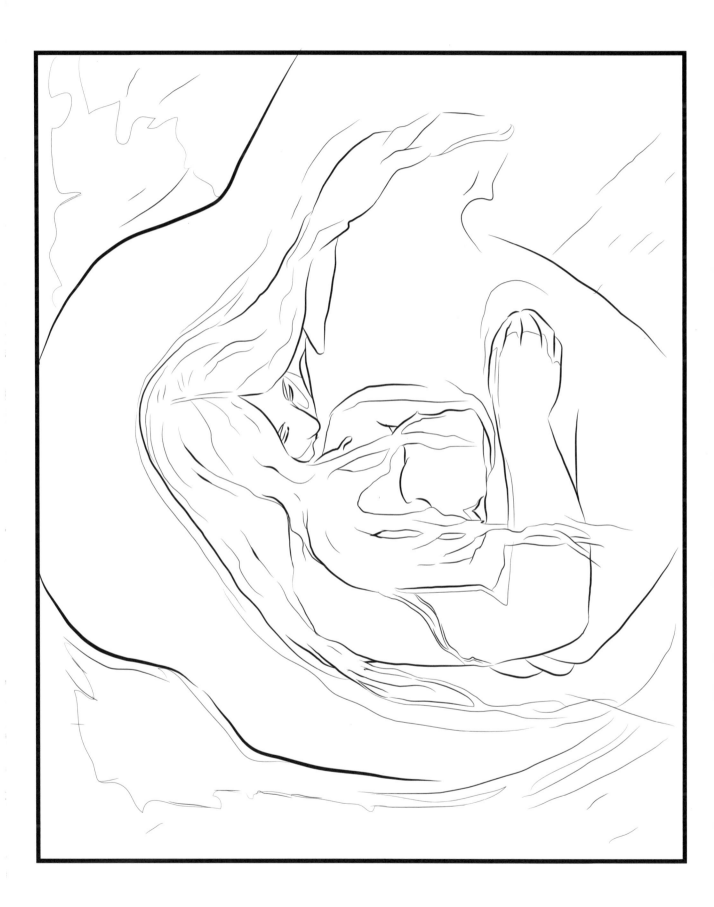

Oil on canvas
115,5 x 93 cm
Munch-museet
MM M 278 (Woll M 602)

E.Munch

Two Girls with Blue Aprons (1904-05)

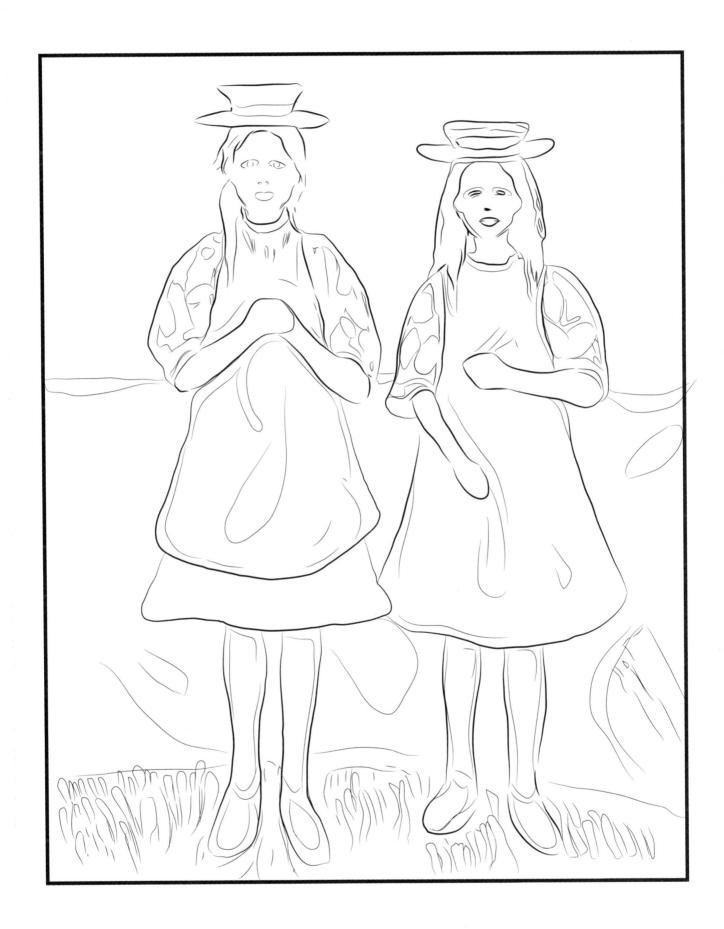

Oil on canvas
120 x 140 cm
Private collection
(Woll M 462)

E.Munch

Fertility (1899-1900)

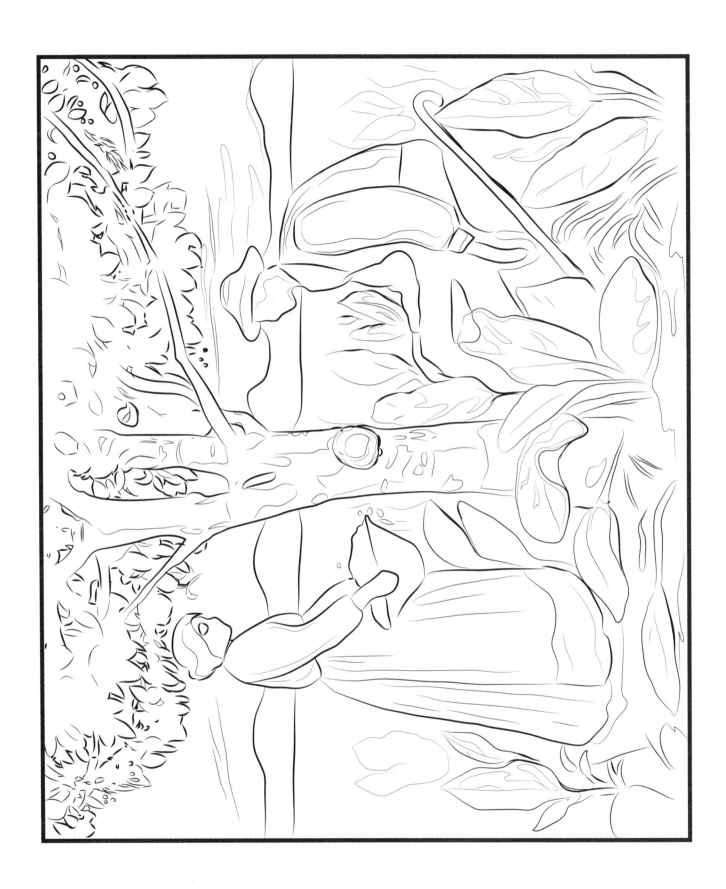

Oil on canvas
118,7 x 121 cm
Tate Modern, London
(Woll M 791)

E.Munch

The Sick Child (1907)

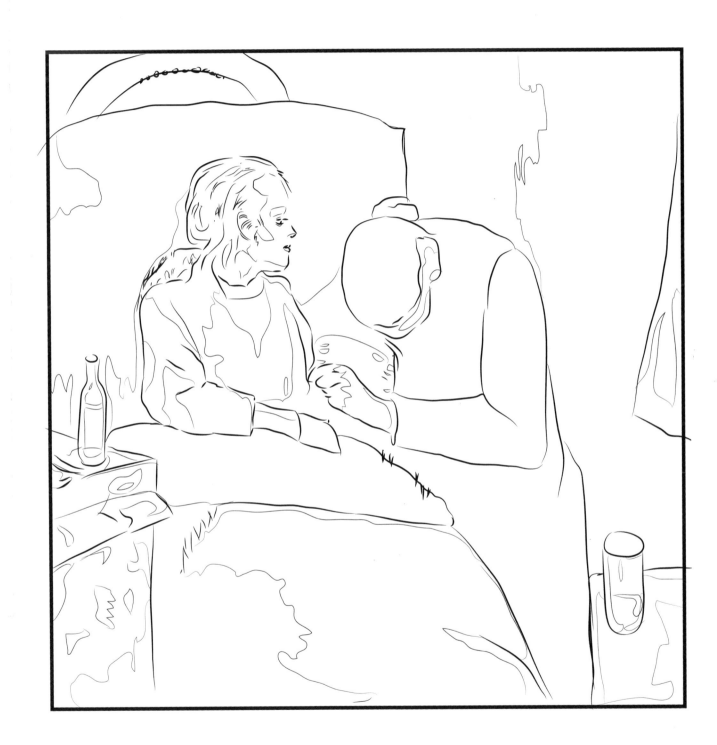

Oil on canvas
93 x 110 cm
Nasjonalmuseet for kunst, arkitektur og design
NG.M.02815 (Woll M 381)

E. Munch

Moonlight (1895)

Oil on canvas
87x111 cm
Munch-museet
M 488

E.Munch

Four Girls in Åsgårdstrand (1903)

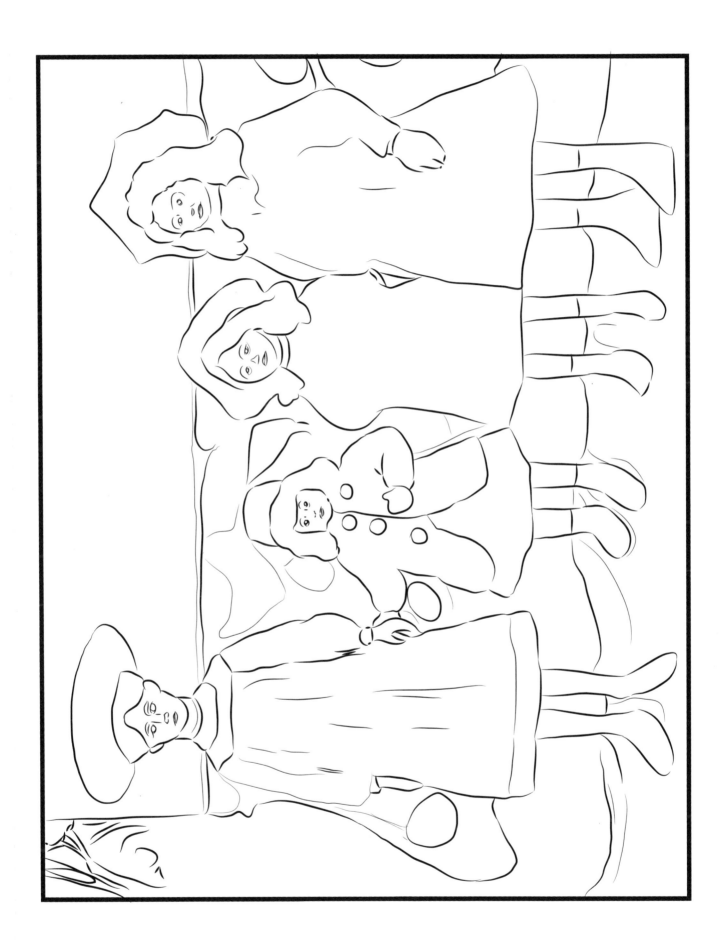

Oil on canvas
203 x 230 cm
Thielska Galleriet, Stockholm
287 (Woll M 567)

E.Munch

The Ladies on the Bridge (1903)

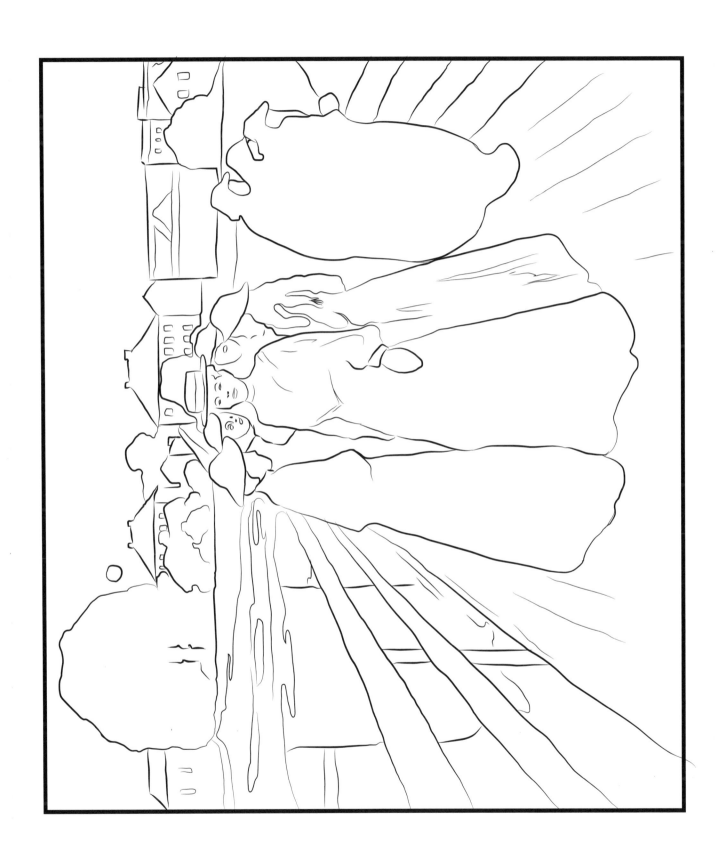

Oil on canvas
120,4x100 cm
Munch-museet
MM M 32 (Woll M 1452)

E.Munr'

Starry Night (1922-24)

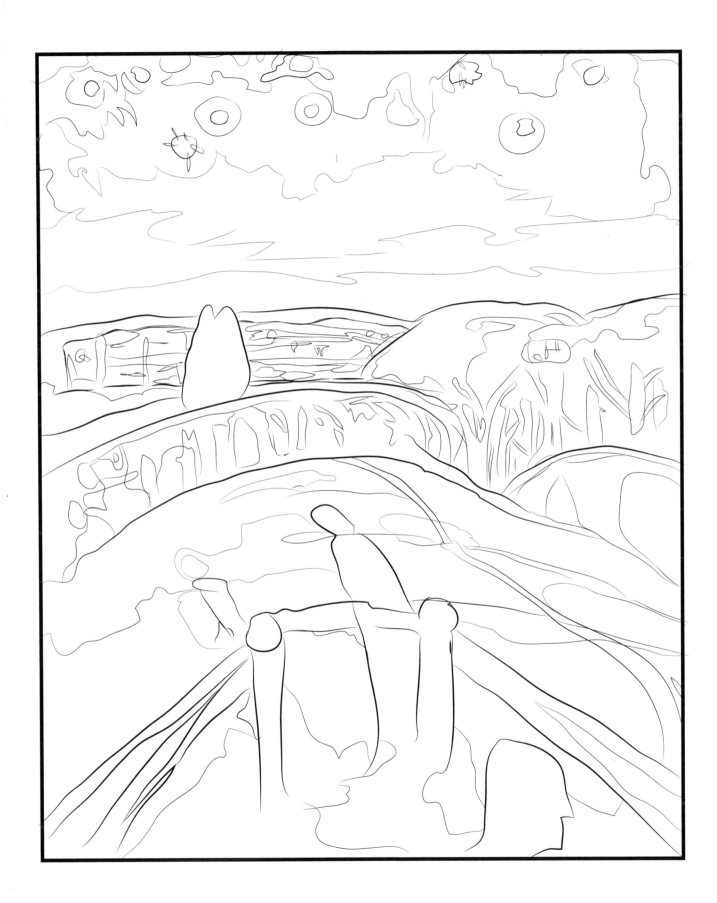

Oil on canvas
139,5 x 200 cm
Munch-museet
MM M 417 (Woll M 1562)

E.Munch

Ashes (1925)

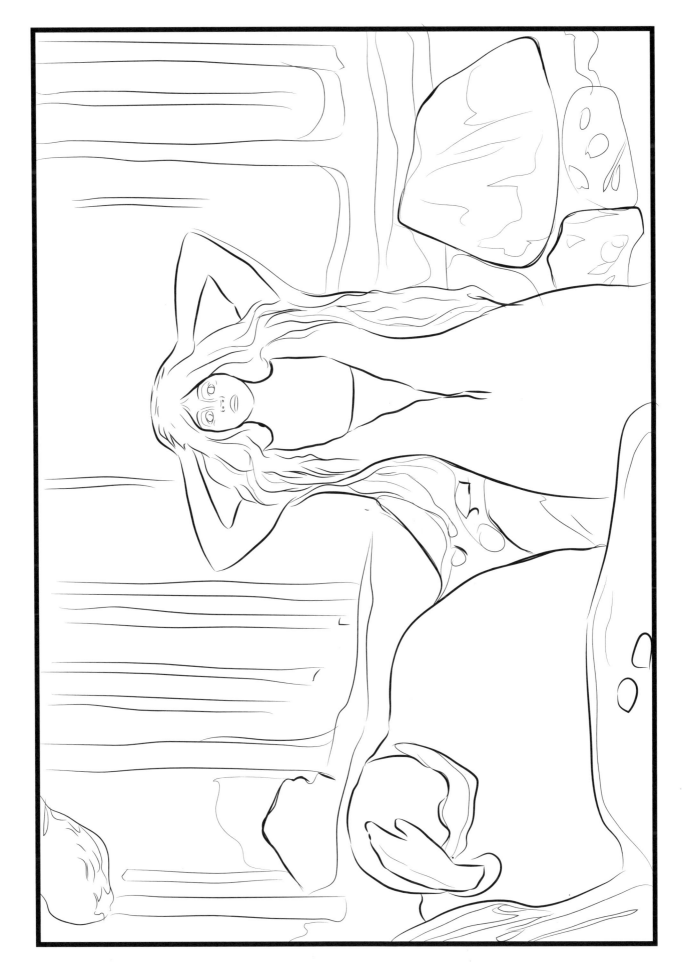

Oil on canvas
91,5 x 73 cm
Munch-museet
MM M 318 (Woll M 1580)

E.Munch

Self-Portrait in Front of the House Wall (1926)

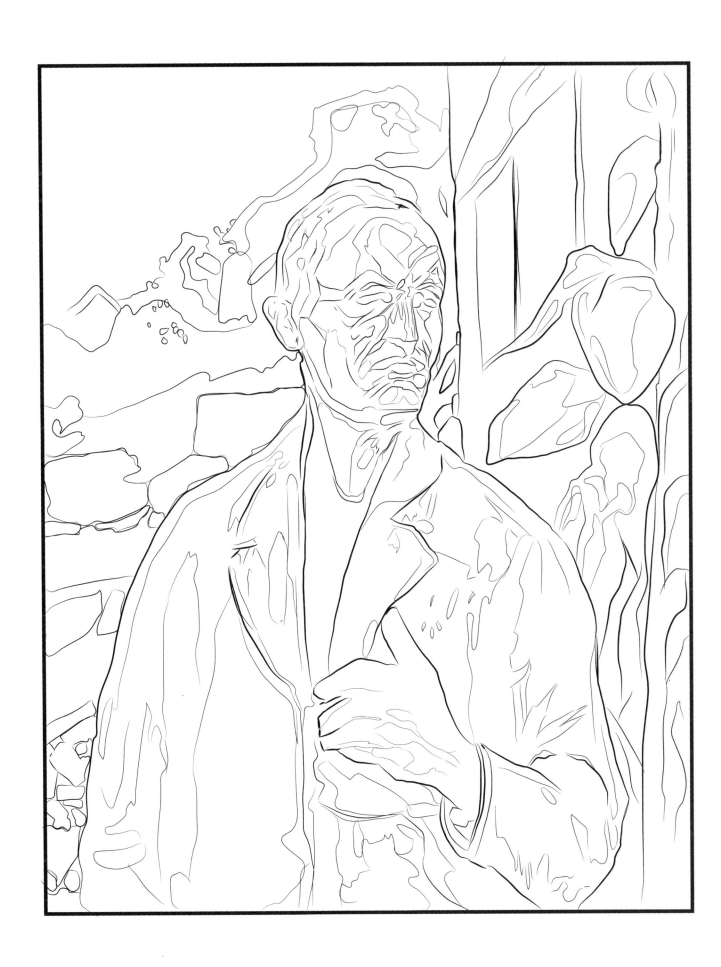

MUNCH
COLOURING BOOK

The following works are the originals behind the drawings:

The Scream (1910)
The Girls on the Bridge (1901)
Dance of Life (1899-1900)
Madonna (1894)
The Fairytale Forest (1901-1902)
Red and White (1899-1900)
Anxiety (ca. 1894)
Hans Jæger (1889)
Puberty (1894-95)
Two Human Beings. The Lonely Ones (1933-35)
Galloping Horse (1910-12)
The Sun (1912)
Vampire (1985)
Two Girls with Blue Aprons (1904-05)
Fertility (1899-1900)
The Sick Child (1907)
Moonlight (1895)
Four Girls in Åsgårdstrand (1903)
The Ladies on the Bridge (1903)
Starry Night (1922-24)
Ashes (1925)
Self-Portrait in Front of the House Wall (1926)

All rights reserved to all works by Edvard Munch:
© Munch-museet / Munch-Ellingsen-gruppen / BONO 2014

Munch Colouring Book
—————————————

©Kontur Publishing 2014
©Illustrations by Niklas Brox, Brox design 2014, courtesy of
Munch-museet / Munch-Ellingsen-gruppen / BONO 2014
Book design: Martin B. Aamundsen

Printed in Latvia, United Press

ISBN 978-82-93053-22-4

www.konturforlag.no

KONTUR
PUBLISHING